Kids Craft World

By
Aditya Kumar Daga

Kids Craft World

Learn & Practice

Blend of Crafts & Arts with varied materials of crafts & many kind of colors & mediums as one will see in my present Book 'Kid's Craft World' give beautiful heart taking effects in Arts.

Selection of different base, medium, type of sketches, Arts, Designs & Colors everything
 matters and kids have to be very visionary and careful in that selection.

Blending & Making Arts with crafts and various new & waste materials make a totally new world of beauty with dazzling & splendid effects

Though it is a difficult task in beginning but very easy to adapt gradually

<div style="text-align: right;">Aditya Kumar Daga</div>

Dedicated To

My Late Parents & All My Family Members

Special Dedication to All Kids & Children who imagine or dream something strange, & love to do art and craft work blending with art & paintings as per their imaginations and dreams which they visualize with their open eyes anywhere at any time.

Kids Craft World

Art & Craft Work envisaged, visualized, developed & made By
Aditya Kumar Daga

3C Gopi Bose Lane Kolkata-700012; W.B; India

www. adityaastroworld@gmail.com

Email: adityaastroworld@gmail.com

Mob: +91 9432221255, +91 8961429776

First Edition on 07th October 2016

Copyright @ Aditya Kumar Daga No Part shall be copied or produced or reproduced without the written permission of the Writer, Artist & Author Aditya Kumar Daga

Material Used in Arts

Plaster Of Paris

Raw Wax

Waste Materials

Raw Cotton

Pieces of Soft Cloth

Transparent Colours

Twinkling Colours

Fabric Colours

Water colours

Fabric Colours

Color Dust

Pencil Skin Wastes

Dried Colours

Boards & Card Boards

Bonding Materials

Process

1. Use your work Area and put some plaster of Paris in desired form
2. Rub softly with soft piece of cloth.
3. Put raw wax for making few items.
4. Use raw cotton for making clouds.
5. Use waste materials for making different small models
6. Use colors as per your own imagination of scenery & colors
7. Use twinkling Colors
8. You make grass, and leaves with threads & cloth pieces
9. Use Water color at some places to give hazy & smooth effects
10. Use fabric Colors at some places to give dense & shine effects.
11. Use twinkling's & sparkling to give dazzle effects.
12. Let the plaster of paris dry properly at some places
13. Use some bonding material with plaster of Paris
14. Some Arts may need mixed colors to give garden effects
15. A few Arts may need ready small animals & models.
16. Use some laminating liquid to give transparency.

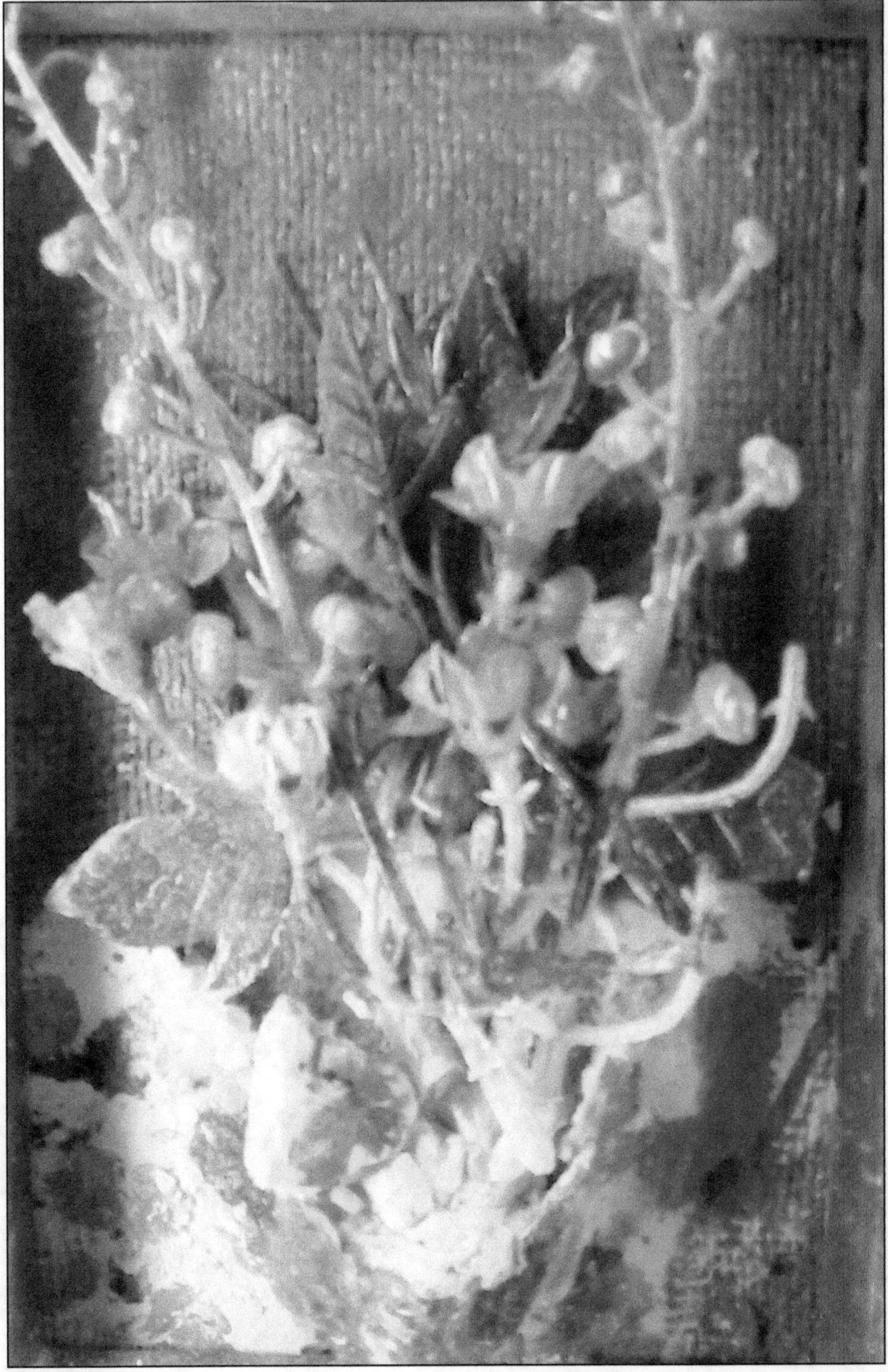

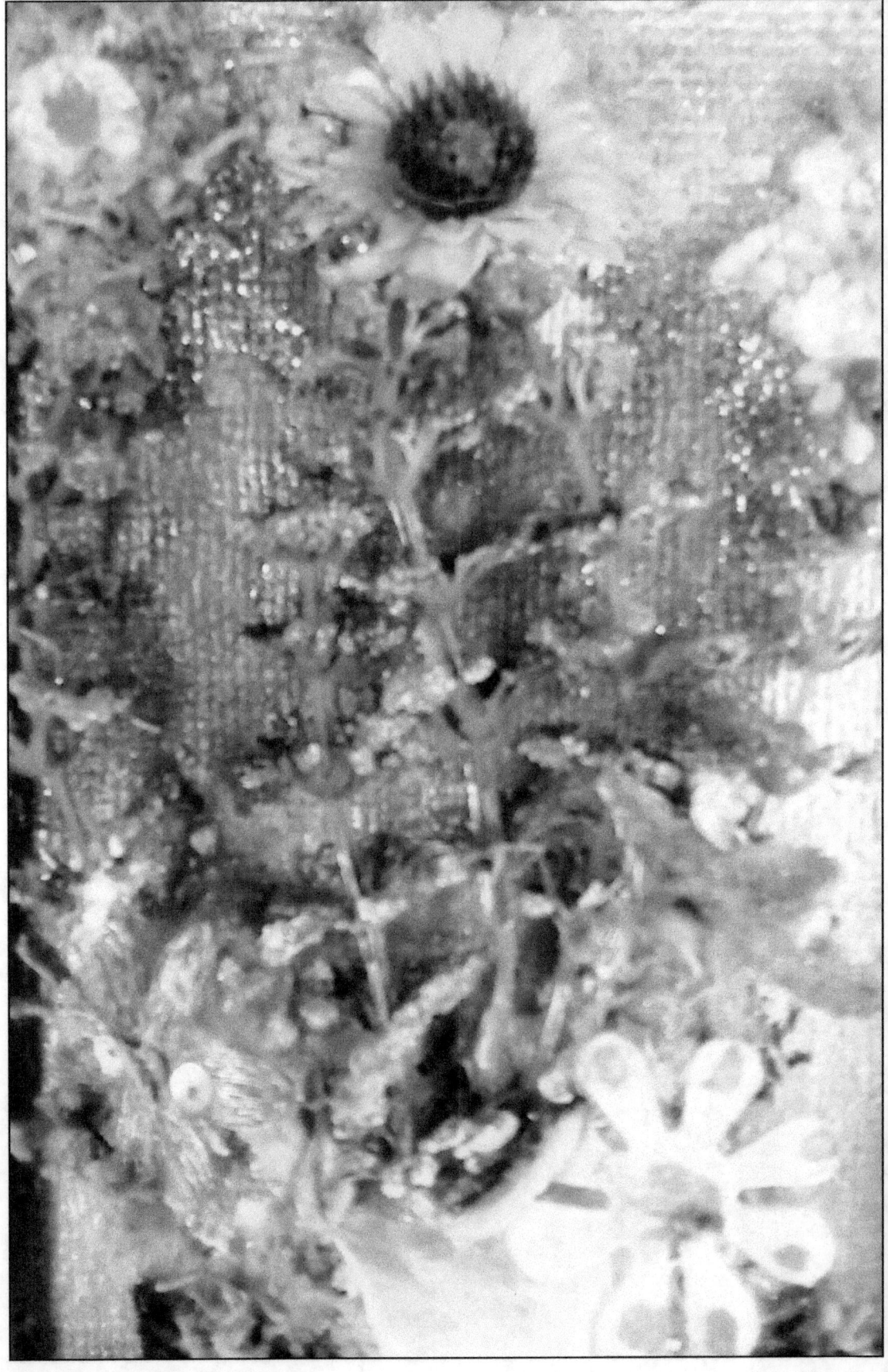

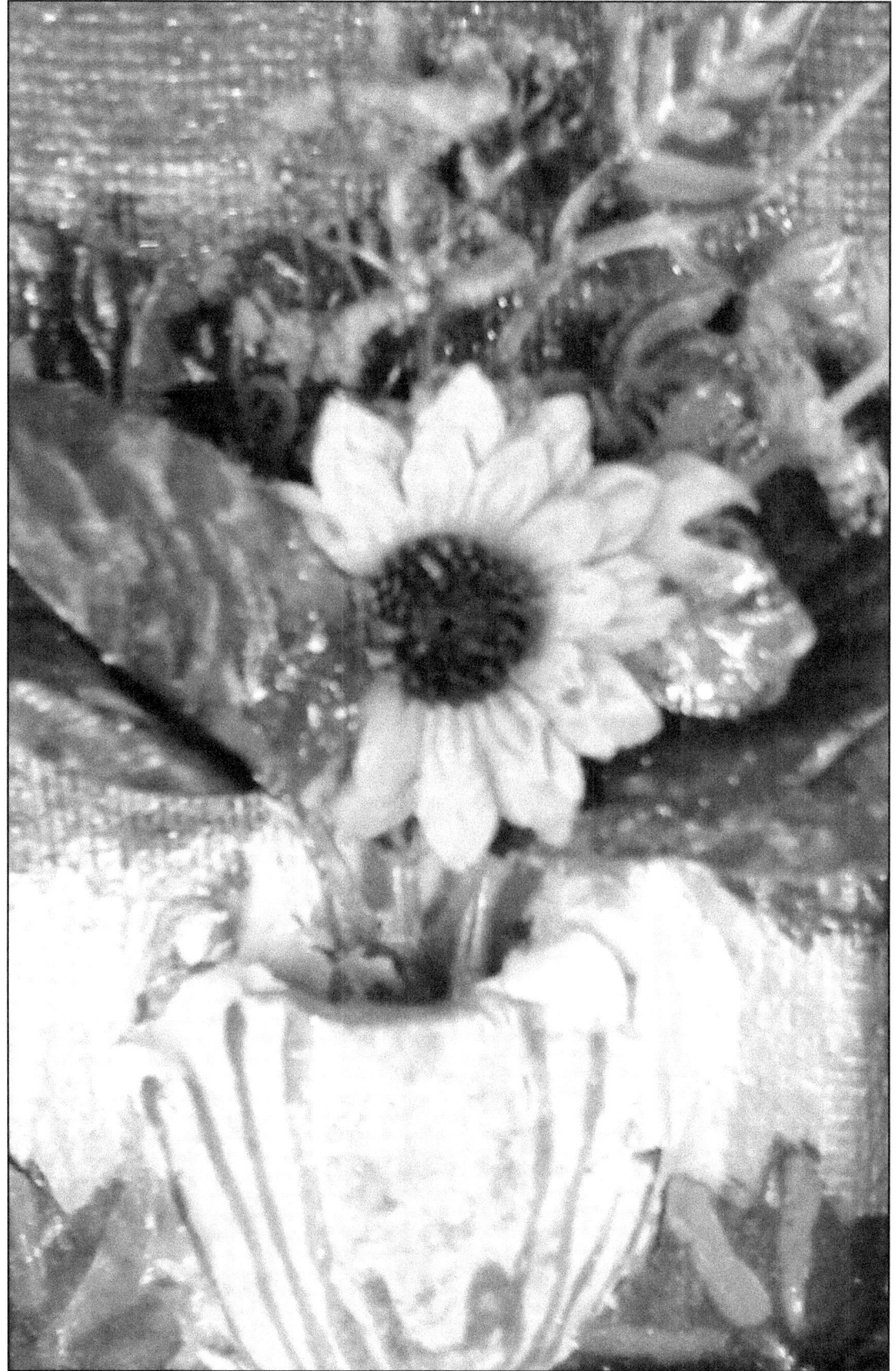

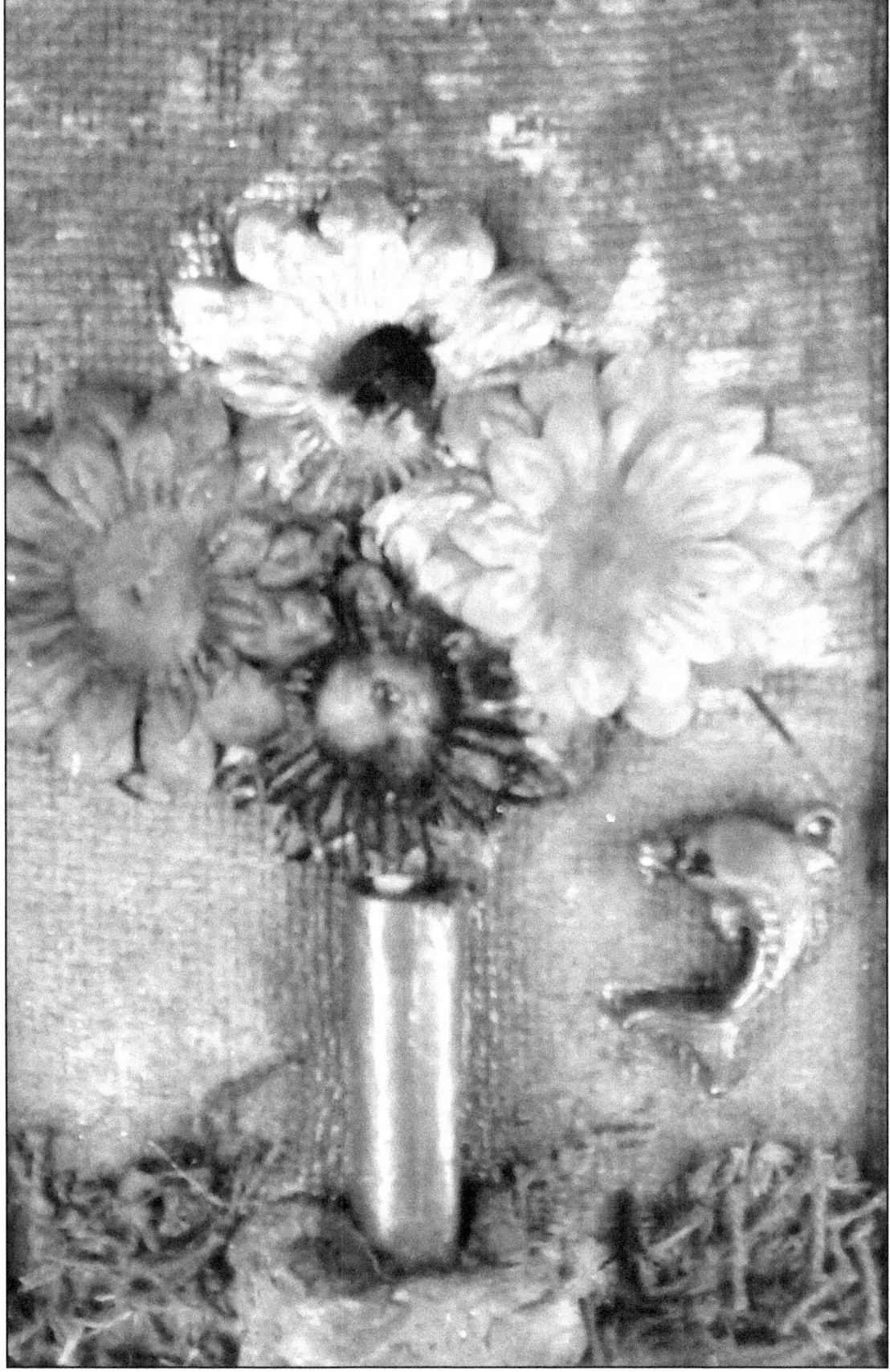

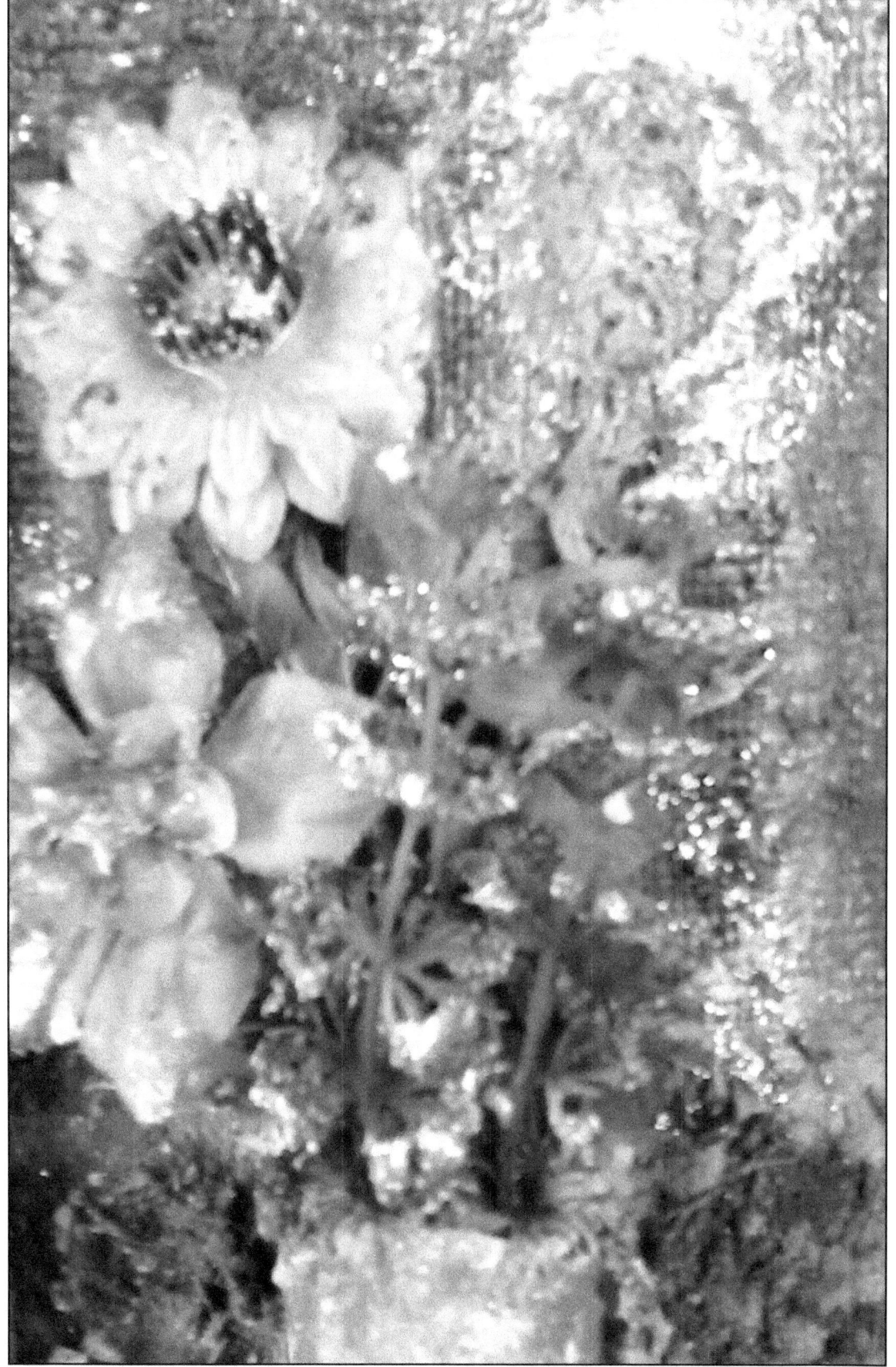

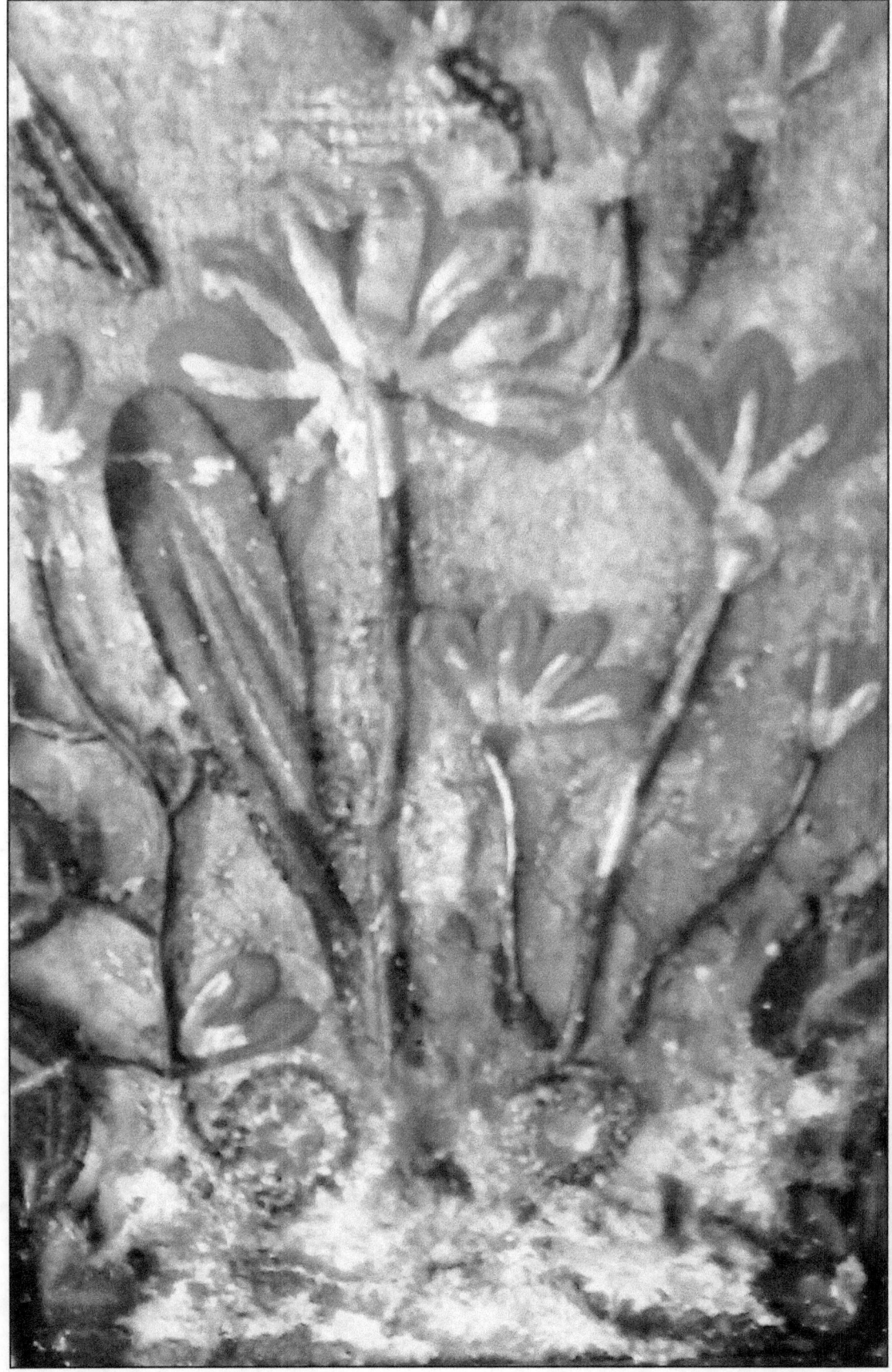

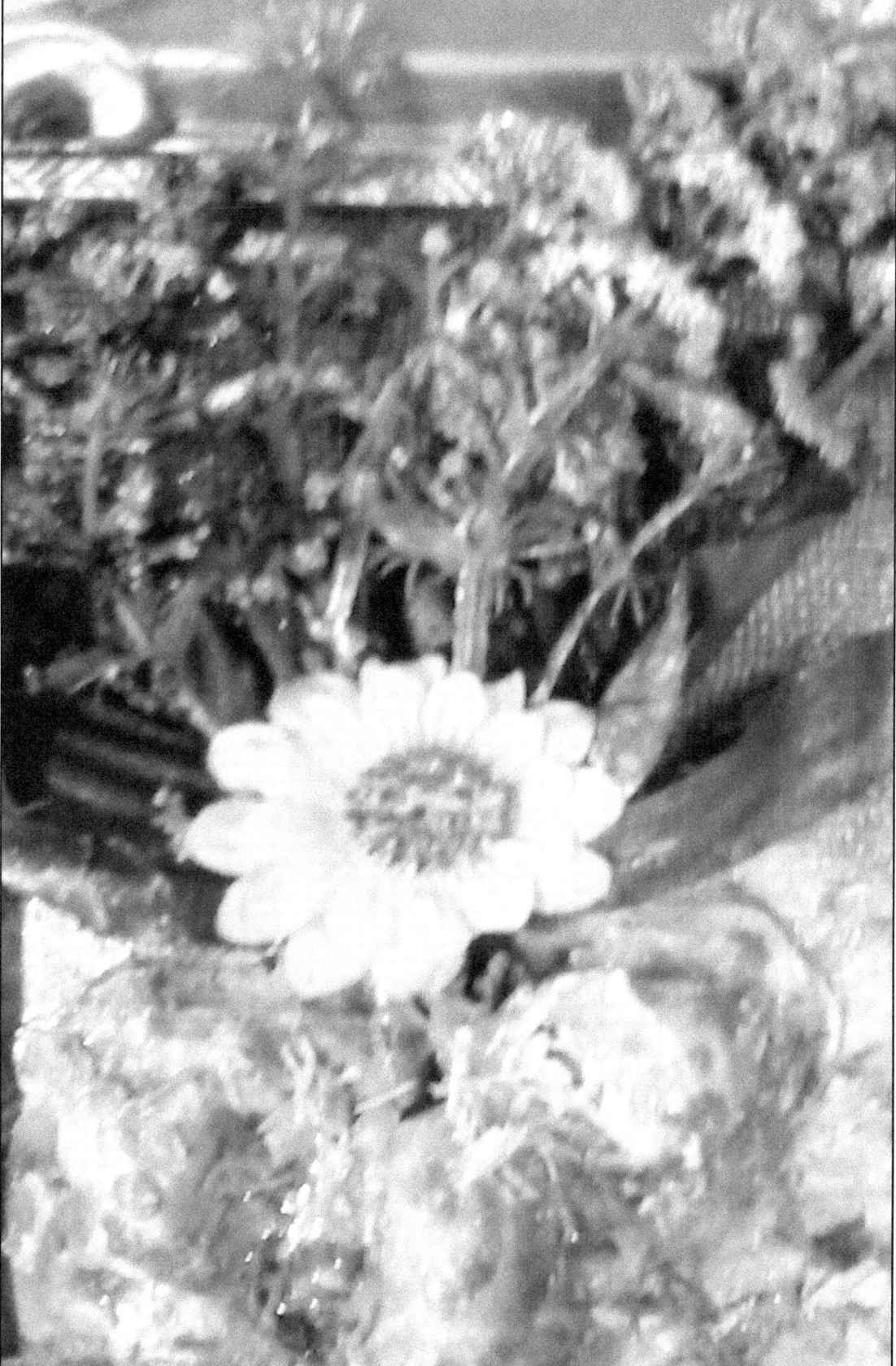

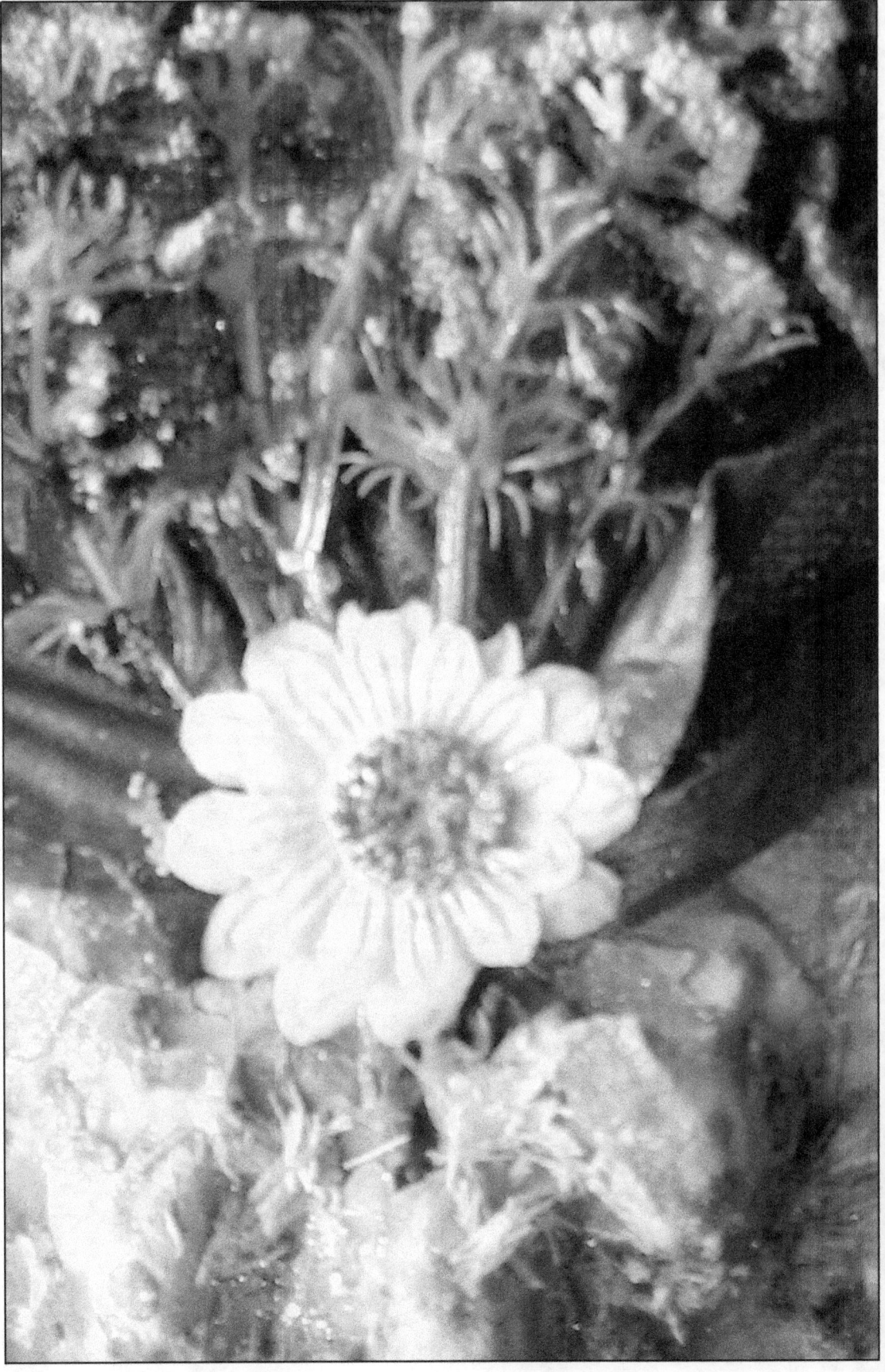

Dear Kid's

Never feel defeated

Never feel dispassionate

Never feel tired

Try to be Simple

Try to be Truthful

Try to be Loyal

Always be Learner

Always be Loving

Always be Cooperative

Always be Honest

Always be Creative

Always be a Performer

This world will definitely recognize you

By Aditya Kumar Daga

Hey ! listen parents, brothers, sisters, friends & my first teachers Thanks for buying me this book : Kids Craft World. Now I'll learn to make a new small beautiful world.

www.ingramcontent.com/pod-product-compliance
Lightning Source LLC
Chambersburg PA
CBHW080526190526

45169CB00008B/3071